D1388035

ABSTRACTS
IN WATERCOLOR

Art Director: Lynne Havighurst
Designer: PandaMonium Designs, Boston, MA
Cover Image: Anne D. Sullivan
 Break Up
 20" x 30" (50.8cm x 76.2cm)
 Strathmore 5-ply high plate
 Media: Acrylic ink, gold inks
Introduction Image: Jean H. Grastorf, A.W.S., N.W.S.
 Endangered
 20" x 32" (50.8cm x 81.3cm)
 Crescent cold press

First published in the United States of America by:
Rockport Publishers, Inc.
146 Granite Street
Rockport, Massachusetts 01966-1299
Telephone: (508) 546-9590
Fax: (508) 546-7141

Distributed to the book trade and art trade in the United States by:
North Light, an imprint of
F & W Publications
1507 Dana Avenue
Cincinnati, Ohio 45207
Telephone: (513) 531-2222

Other Distribution by:
Rockport Publishers
Rockport, Massachusetts 01966-1299

ISBN 1-56496-244-X

10 9 8 7 6 5 4 3 2 1

Printed and bound in Hong Kong

ABSTRACTS
IN WATERCOLOR

SELECTED BY

BETTY LOU SCHLEMM

ROCKPORT PUBLISHERS
ROCKPORT, MASSACHUSETTS

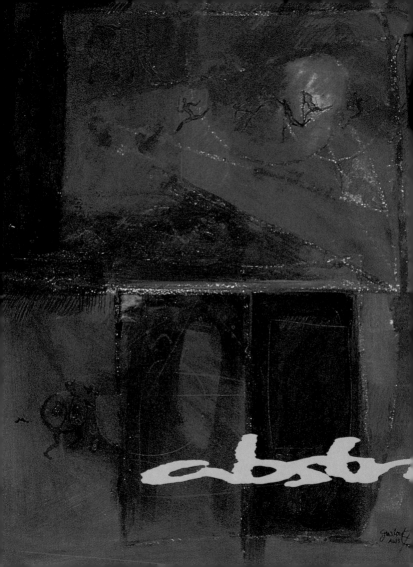

INTRODUCTION

What causes a viewer to pass by one abstract painting, yet be caught in the aura of another, perhaps for a lifetime? How is it that the arrangement of color, line, and shape with certain rhythms and textures can evoke such disparate, provocative responses?

There is a correspondence of visual abstraction with that of music. It is found in the specific moods, memories, ideas, or images that a particular shape, melody, color, sound, texture, rhythm, touch, or timbre can provoke in an audience. Colors and shapes—like sounds—reverberate messages.

Ultimately, a portrait may convey the essence of an existence more convincingly through abstract language than is possible within the limitations of narrative or realist traditions.

Abstraction is part poetry, part music, part mathematics, and part philosophy: a substance pondered, filtered, and condensed to its considerable essence. It is not a static symbol, but a potent philter. The source of good abstraction is in truth, and in its basis in reality: its power resides there. Without this veracity, abstraction becomes a friable, ephemeral trifle, and we move on untouched. With truthfulness we engage in the unshakable power and philosophy of great abstraction.

Erica Adams
Painting Faculty
Tufts University
School of the Museum
of Fine Arts, Boston

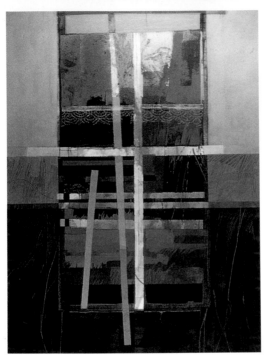

△ **Al Brouillette**
Dimensions IV
30" x 22" (76.2cm x 55.9cm)
Strathmore 500
Mixed media: Acrylic, collage

▷ **Al Brouillette**
Dimensions IX
30" x 22" (76.2cm x 55.9cm)
Strathmore 500
Mixed media: Acrylic

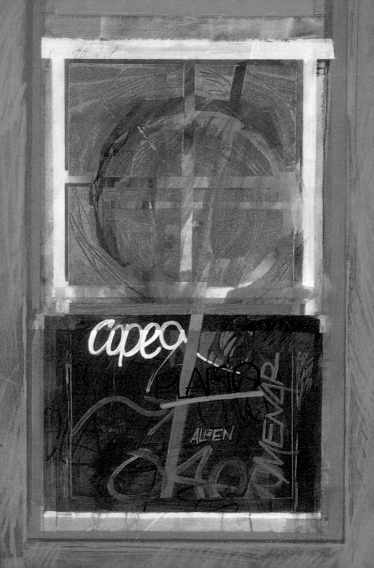

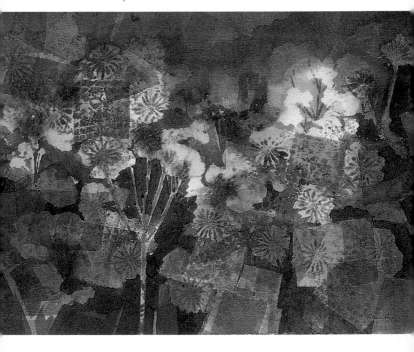

▽ **Patricia Reynolds,**
M.W.S.
October Patchwork
22" x 30" (55.9cm x 76.2cm)
Arches 400 lb. cold press

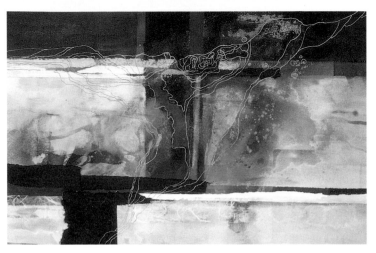

△ **Marie Shell**
Layers of Thought
22" x 30"(55.9cm x 76.2cm)
Arches 300 lb. cold press

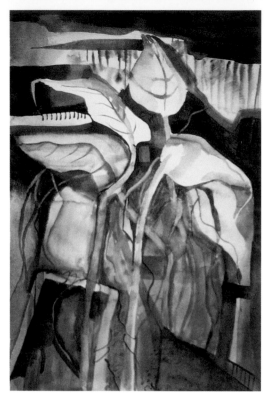

△ **Kathleen Barnes**
New Growth
15" x 20" (38.1cm x 50.8cm)
Strathmore Aquarius 90 lb.

▽ **Kathleen Barnes**
In Neutral
20" x 30" (50.8cm x 76.2cm)
140 lb. rough
Mixed media: Charcoal, gold lcaf

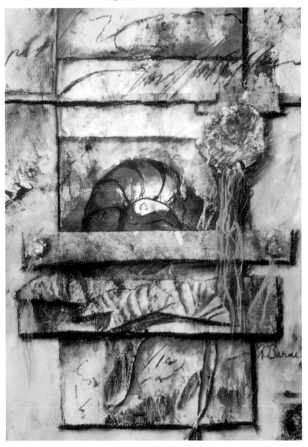

▷ **Edwin H. Wordell**
Autumn Nocturne
20" x 16" (50.8cm x 40.6cm)
Rag Board
Mixed media: Mixed watermedia, gouache

▽ **Maxine Custer**
Inner Memories
22" x 30" (55.9cm x 76.2cm)
140 lb. watercolor paper

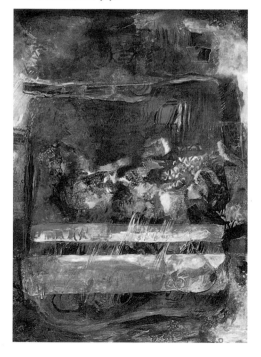

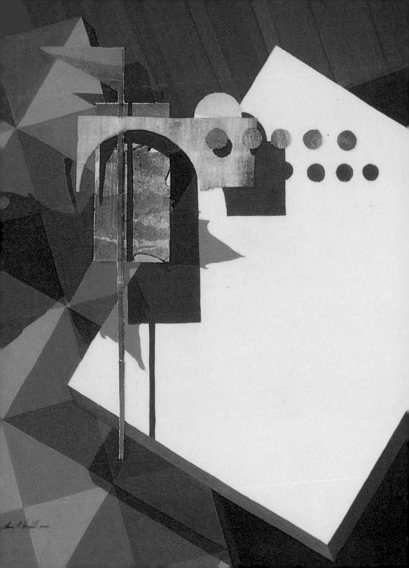

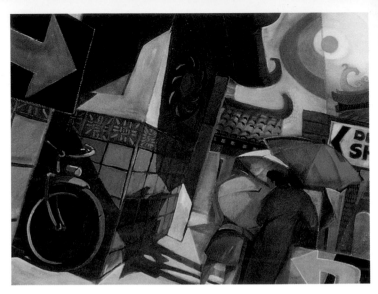

△ **Roy E. Swanson,**
M.W.S.
The Bard
21" x 29" (53.3cm x 73.6cm)
Arches 140 lb. cold press

∇ **Betty Jo Fitzgerald**
In Search of Nexus #2
30" x 22" (76.2cm x 55.9cm)
Arches 140 lb. cold press
Mixed media: Charcoal, pastel,
pencil, sumi ink, acrylic

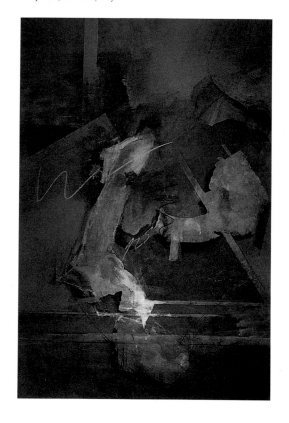

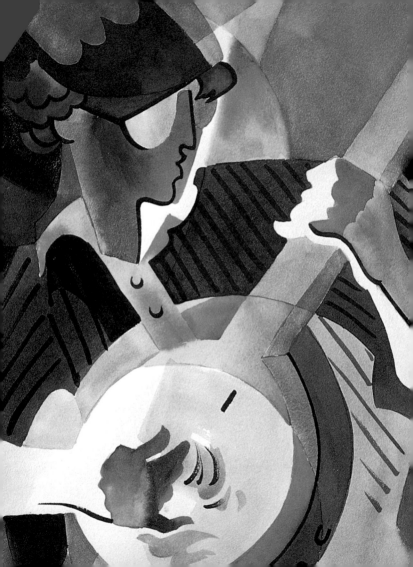

∇ **Avie Biedinger**
Day Star Et Al
23.5" x 34" (59.7cm x 86.4cm)
Rag illustration board
Mixed media: Transparent watercolor,
watercolor crayon

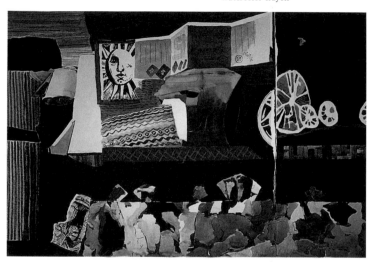

◁ **Michael Schlicting**
Waiting For The Bus
22" x 30" (55.9cm x 76.2cm)
Arches 300 lb. cold press
Mixed media: Transparent watercolor,
gouache, watercolor crayon, watercolor pencil

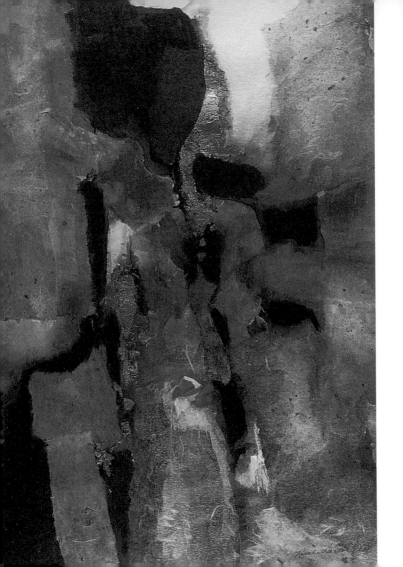

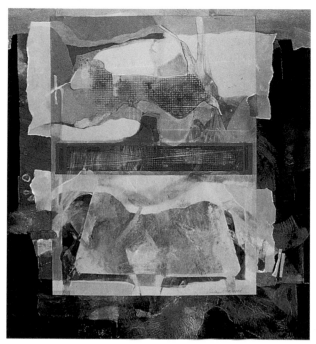

△ **Linda C. Hammond**
Run Rabbit Run
30" x 40" (76.2cm x 101.6cm)
Crescent
Mixed media: Acrylic, Prismacolor paint,
watercolor pencil

◁ **Rosalie Harris-Cecil**
Copper Canyon
14" x 19" (35.6cm x 48.3cm)
Arches 140 lb. cold press
Mixed media: Collage, transparent watercolor, acrylic

▽ **Carmela C. Grunwaldt**
Conversion
30" x 40" (76.2cm x 101.2cm)
Mixed media: Previously painted
paper, non-woven fabric

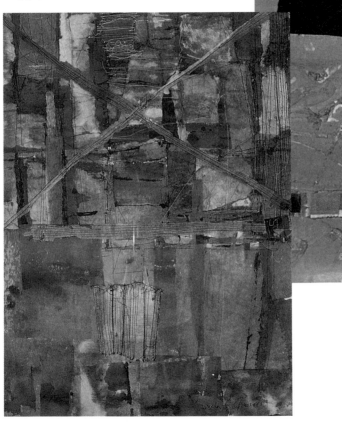

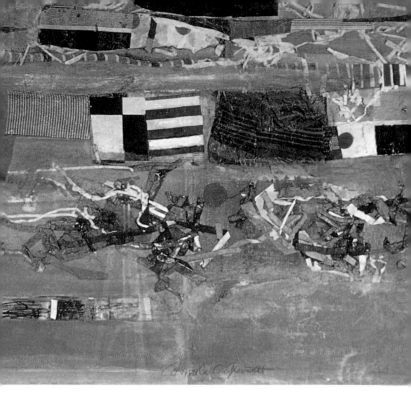

△ **Carmela C. Grunwaldt**
Parade
30" x 40" (76.2cm x 101.2cm)
Illustration board
Mixed media: Ink, diluted acrylic,
cloth, paper, wax, pastel pencil

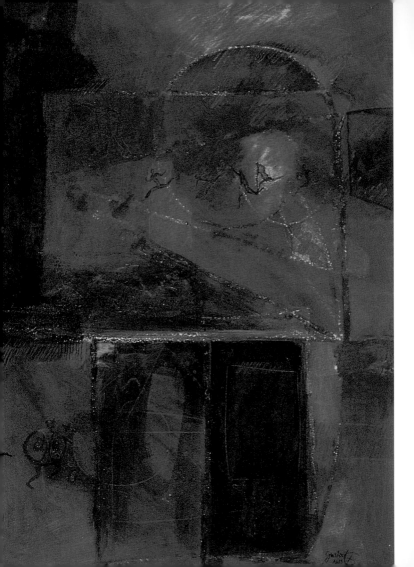

Jean H. Grastorf,
A.W.S., N.W.S.
Endangered
20" x 32" (50.8cm x 81.3cm)
Crescent cold press

Betty Lynch,
A W S
Visitors to the Past
21" x 27" (53.3cm x 68.6cm)
Arches 140 lb. cold press

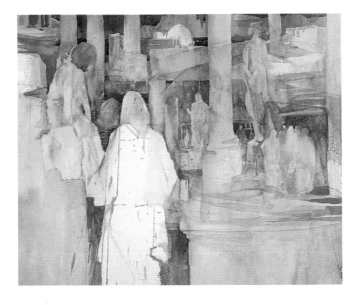

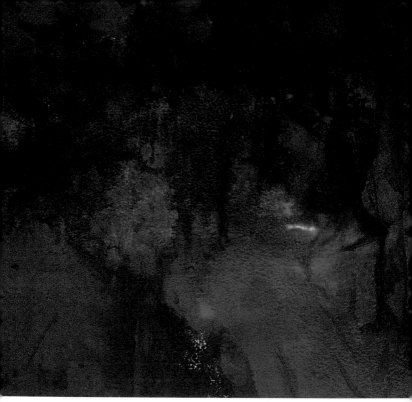

△ **Karin Wilson**
The Forest
21" x 26" (53.3cm x 66.0cm)
Arches 140 lb.
Mixed media: Ink, acrylic

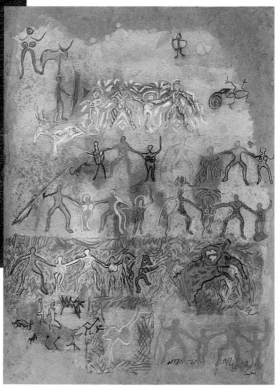

▽ **Dee Gaylord**
Party Animals
30.5" x 38" (77.5cm x 96.5cm)
Strathmore Aquarius II 180 lb.
Mixed media: Acrylic, watercolor pencil

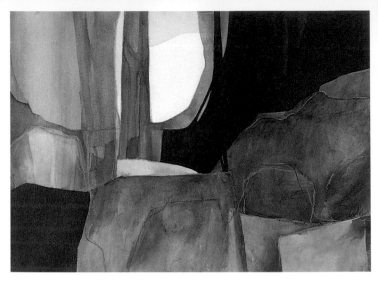

△ **Dorothy B. Dallas**
New Forest
22" x 30" (55.8cm x 76.2cm)
Arches 140 lb. cold press
Mixed media: Watercolor crayon

▽ **Dorothy B. Dallas**
Sarsen III
18" x 24" (45.7cm x 61.0cm)
Arches 140 lb. hot press
Mixed media: Watercolor crayon,
rice paper, gouache

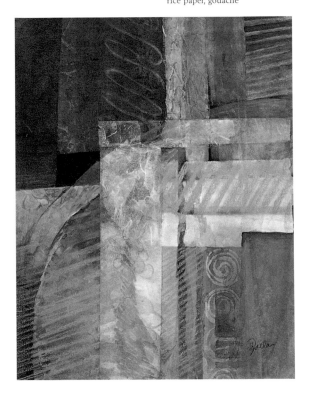

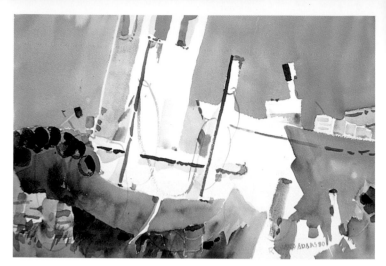

△ **Richard Adams**
Lil' Old Tug
15" x 22" (38.1cm x 55.8cm)
Arches 140 lb. cold press

▷ **Mary Britten Lynch**
Caribbean Blues
30" x 20" (76.2cm x 50.8cm)
Strathmore 112 lb. rough
Mixed media: Transparent
watercolor, acrylic, gesso

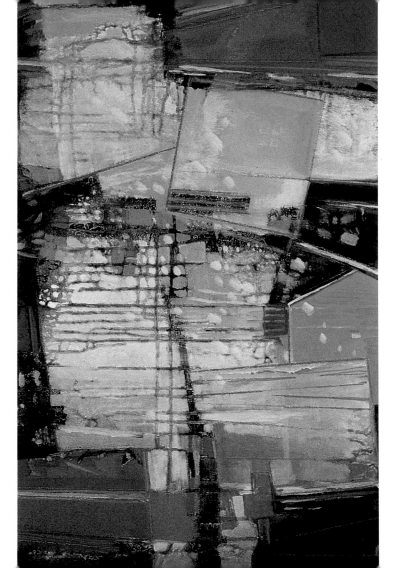

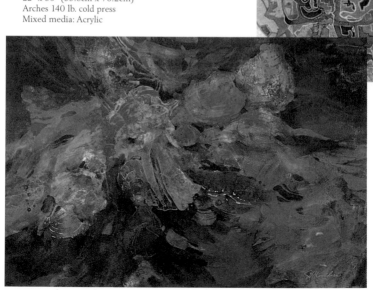

∀ **Joyce H. Kamikura,**
F.C.A., N.W.S.
Oceanic Honey
22" x 30" (55.8cm x 76.2cm)
Arches 140 lb. cold press
Mixed media: Acrylic

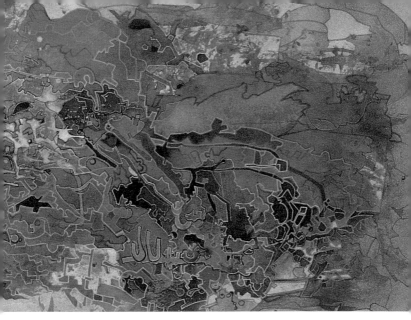

A **Yee Wah Jung**
Before Sunset
23" x 36" (58.4cm x 91.4cm)
Arches 140 lb.
Mixed media: Acrylic

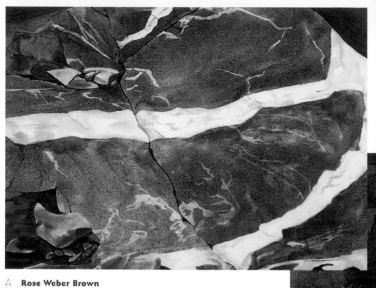

△ **Rose Weber Brown**
Blue Granite
30" x 40" (76.2cm x 101.6cm)
Crescent #114
Mixed media: Gouache

▽ **(Barbara) Ara Leites,**
N.W.S.
Legacy II
30" x 22" (76.2cm x 55.8cm)
Strathmore Excalibur
Mixed media: Acrylic

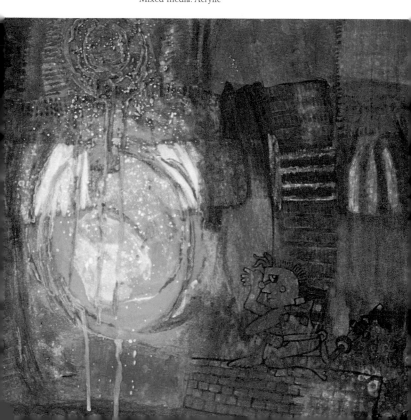

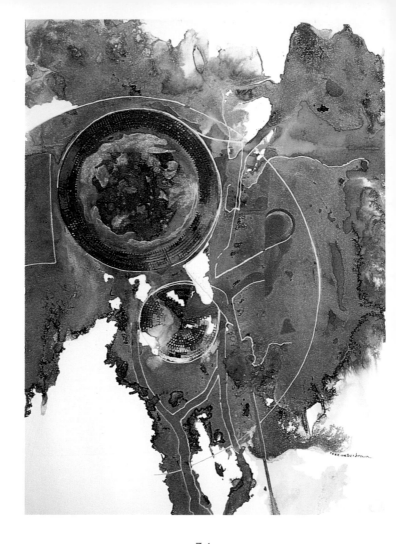

◁ **Rose Weber Brown**
Spinoff
30" x 22" (76.2cm x 55.8cm)
Strathmore Aquarius
Mixed media: Permanent ink, acrylic

▽ **Linda C. Hammond**
Elegy
30" x 40" (76.2cm x 101.6cm)
Crescent
Mixed media: Acrylic,
Prismacolor paint, gel metallic

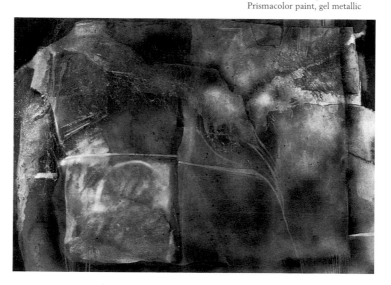

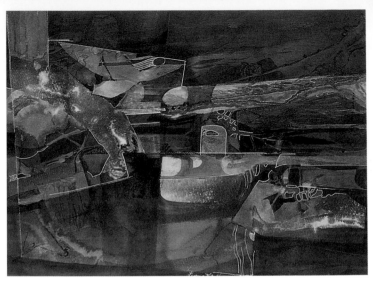

△ **Lynne Kroll**
Landscape Weave IV
22" x 30" (55.8cm x 76.2cm)
Arches 140 lb. cold press
Mixed media: Watermedia, ink, silver
metallic pen, gouache

▷ **Betty Blevins**
Wild n' Free
30" x 22" (76.2cm x 55.8cm)
Arches 140 lb. cold press
Mixed media: Acrylic

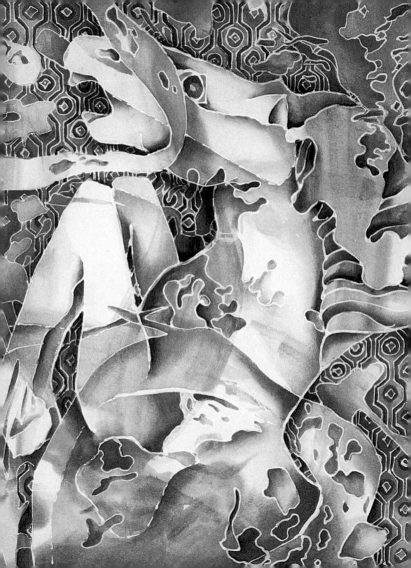

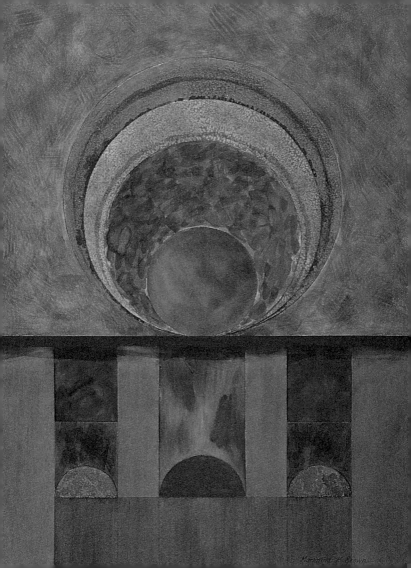

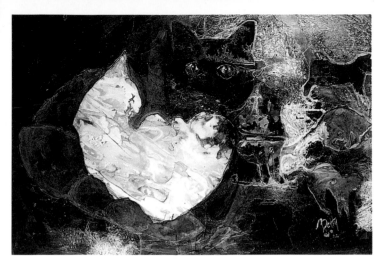

A **Betty Sheasgreen**
Marble Cats
20" x 30" (50.8cm x 76.2cm)
Plate illustration board
Mixed media: Water-based ink

Marianne K. Brown
Desert Image
30" x 22" (76.2cm x 55.8cm)
Arches 140 lb. cold press

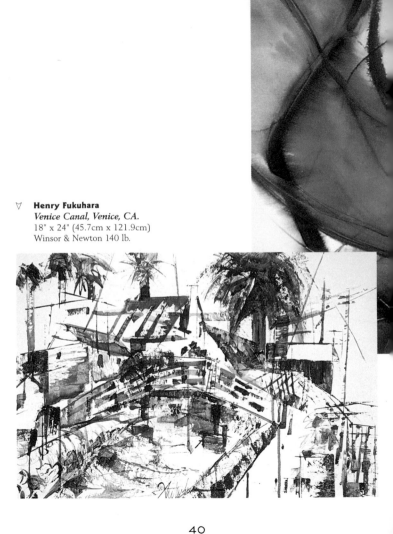

Henry Fukuhara
Venice Canal, Venice, CA.
18" x 24" (45.7cm x 121.9cm)
Winsor & Newton 140 lb.

A **Bernyce Alpert Winick**
Ardito
40" x 60" (101.6cm x 152.4cm)
Arches 300 lb. cold press

△ **Virginia Blackstock**
Family Panel - Nile Mile Canyon
28" x 36" (71.1cm x 91.4cm)
Arches 140 lb. cold press

Donne F. Bitner
Reliquary #2
30" x 22" (76.2cm x 55.8cm)
Strathmore Aquarius II 90 lb. cold press
Mixed media: Tube acrylic, watercolor crayon

▽ **Babs Scott**
Sacred Relics
29" x 37" (73.6cm x 94.0cm)
Lana Aquarelle 140 lb.
Mixed media: Acrylic

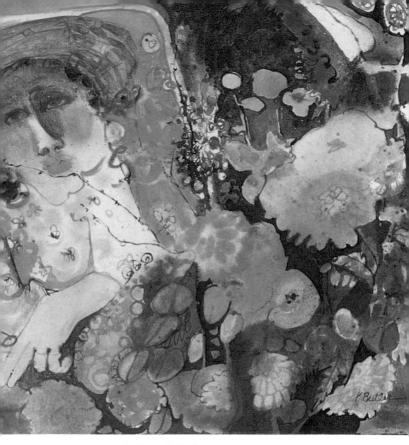

△ **Karen B. Butler**
Charlotte's Garden
22" x 30" (55.8cm x 76.2cm)
E.H. Saunders 140 lb. cold press

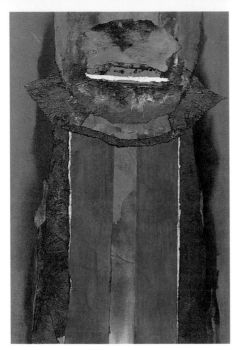

△ **Carol Rennick**
Spirit I
19" x 25" (48.3cm x 63.5cm)
Cold press
Mixed media: Watercolor collage,
metallic watercolor, rice paper

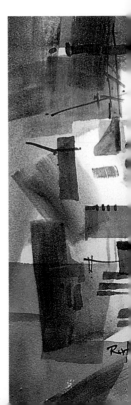

▽ **Ratindra K. Das,**
M.W.S., N.W.S.
Havegard F.S
15" x 22" (38.1cm x 55.8cm)
Arches 140 lb. cold press

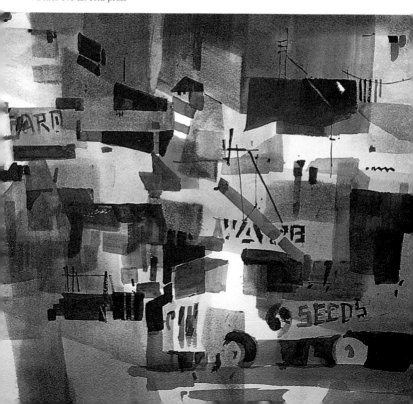

▽ **Betty M. Bowes**
I Must Go Down to the Sea Again
20" x 24" (50.8cm x 61.0cm)
300 lb.

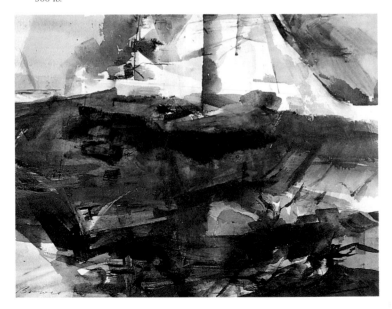

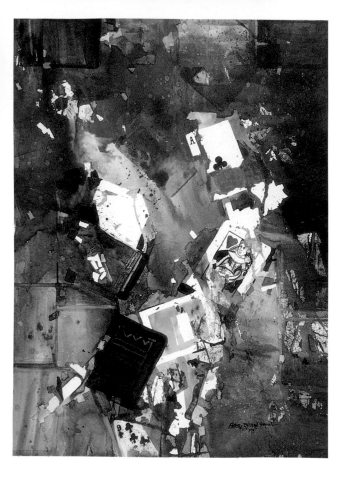

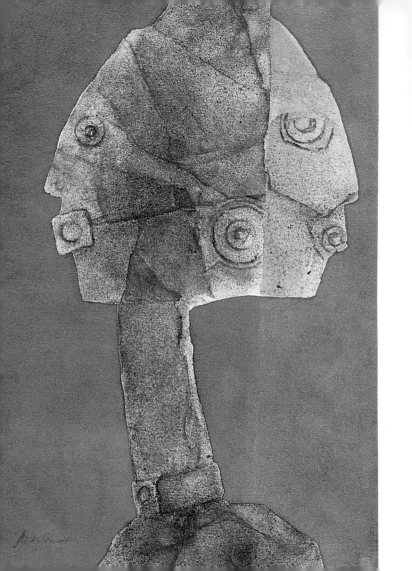

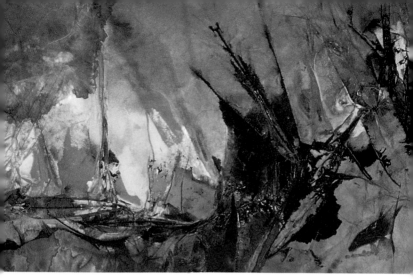

A **Bernyce Alpert Winick**
Appoggiatura
36" x 72" (91.4cm x 182.9cm)
Rice paper

Aida Schneider
Nefertiti—Alter Ego
22" x 15" (55.8cm x 38.1cm)
Arches 300 lb. cold press

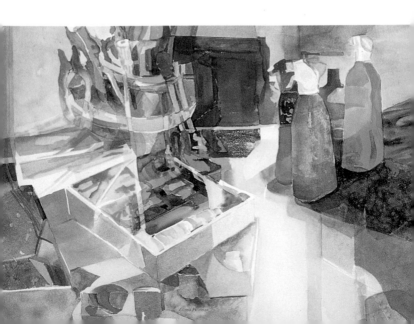

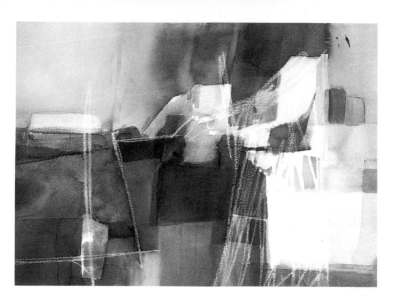

Gloria Paterson
Arena
22.5" x 33.5" (57.2cm x 85.1cm)
Arches 140 lb. cold press
Mixed media. Crayon resist

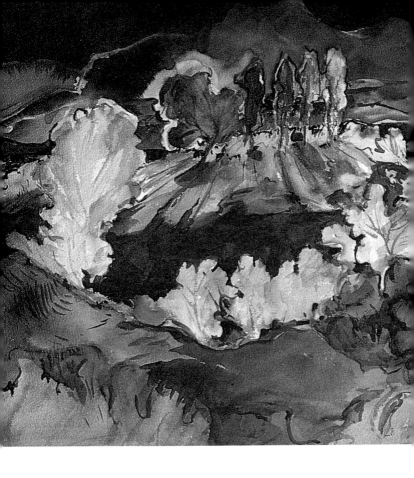

◁ **Louise L. Barratt**
Highway Series
22" x 30" (55.8cm x 76.2cm)
140 lb. Rag

▽ **Allan Hill**
Dream Reaches
22.25" x 29.75" (56.5cm x 75.6cm)
Arches 140 lb.

∀ **Sue Reynolds**
Canyon I
32" x 40" (81.3cm x 101.6cm)
Strathmore Aquarius II
Mixed media: Collage, gouache

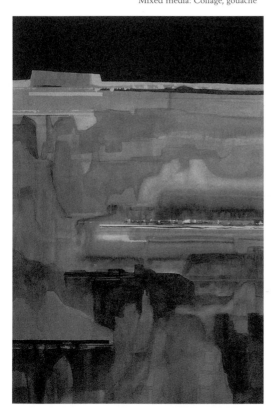

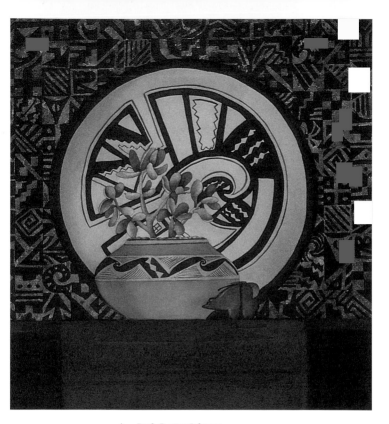

△ **Beth Porter Johnson**
Standing Guard
21" x 21" (53.3cm x 53.3cm)
Arches 140 lb. cold press
Mixed media: Transparent
watercolor, acrylic

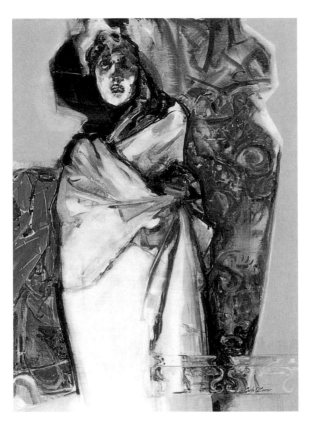

 Carla O'Connor
Japanese Porcelain
30" x 22" (76.2cm x 55.8cm)
Hot press watercolor board
Mixed media: Metallics

▽ **Revelle Hamilton**
Leaves of Frost
16" x 20" (40.6cm x 50.8cm)
Multimedia art board
Mixed media: Acrylic

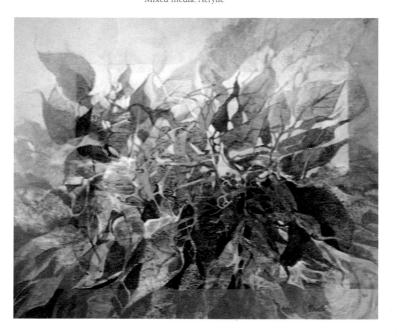

▽ **Pat Deadman,**
A.W.S., N.W.S.
Container Series
22" x 30" (55.8cm x 76.2cm)
Arches 140 lb. cold press

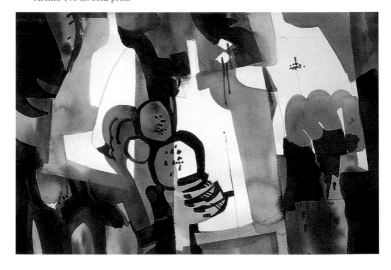

A **Anne D. Sullivan**
Connections
30" x 40" (76.2cm x 101.6cm)
Strathmore 5-ply high plate
Mixed media: Acrylic ink,
Prismacolor pencil

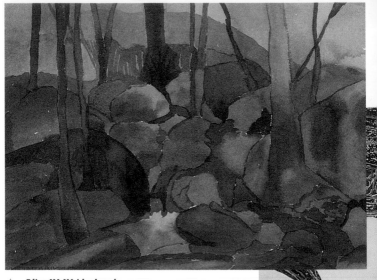

A **Alice W. Weidenbusch**
French Creek
6" x 9.5" (15.2cm x 24.1cm)
Arches 140 lb. cold press

▽ **Phyllis Hellier,**
F.W.S., G.W.S., N.O.W., K.W.S.
Entwined Revisited
22" x 30" (55.8cm x 76.2cm)
Arches 300 lb. cold press 100% rag
Mixed media: Acrylic

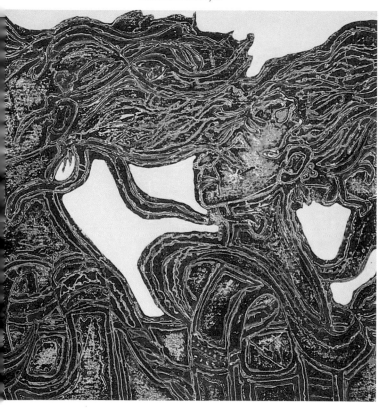

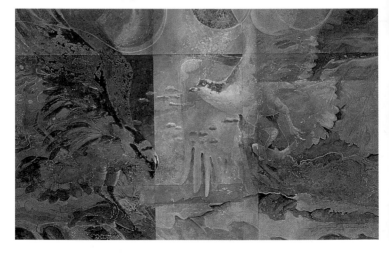

▽ **Joan Ashley Rothermel,**
A.W.S.
De Profundis
30" x 40" (76.2cm x 101.6cm)
Strathmore Print 90
Mixed media: Gouache, lightfast ink

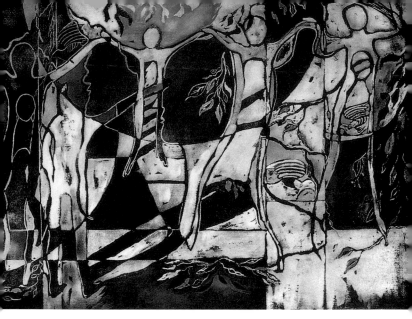

△ **Phyllis Hellier,**
F.W.S., G.W.S., N.O.W., K.W.S.
Dance By The Midnight Sun
22" x 30" (55.8cm x 76.2cm)
Arches 300 lb. cold press 100% rag
Mixed media: Gouache, ink

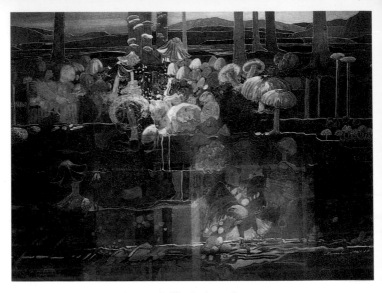

A **Joan Ashley Rothermel,**
A.W.S.
D.S. Mushrooms
28" x 36" (71.1cm x 91.4cm)
Strathmore Print 90
Mixed media: Gouache,
lightfast ink, watercolor pencil

∀ **Diane Lounsberry-Williams**
Indigo Edge
32" x 40" (81.2cm x 101.6cm)
4-Ply rag
Mixed media: Acrylic

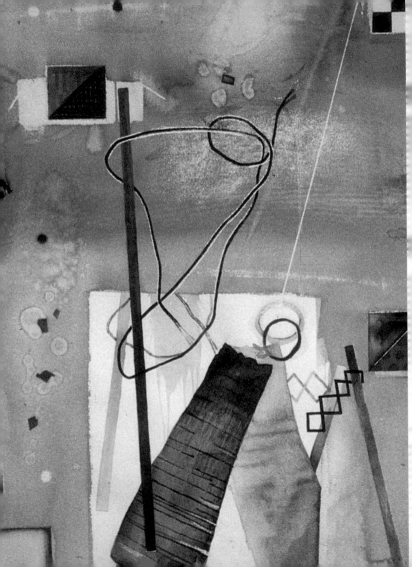

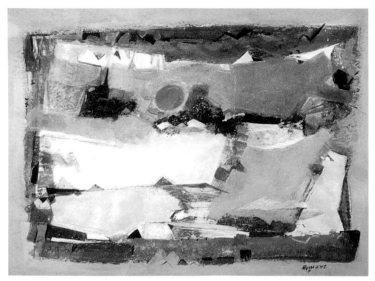

△ **Carole Myers,**
A.W.S., N.W.S.
Song of the Southwest
30.5" x 41" (77.5cm x 104.1cm)
Morilla 140 lb. cold press

◁ **Robert Lee Mejer**
Variant: Precious Places
30" x 22.5" (76.2cm x 57.2cm)
Arches 140 lb.

∇ **Paul G. Melia**
Venetian Fantasy
41" x 41" (104.1cm x 104.1cm)
Crescent and 2- and 3-ply Strathmore bristol
Mixed media: Permanent ink, gouache

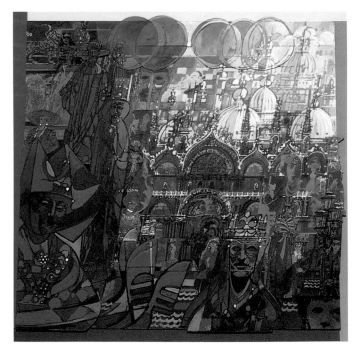

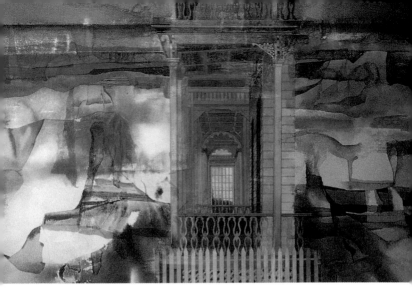

A **Jean F. Leary**
A Heartbeat Away
21" x 26" (53.3cm x 66.0cm)
Strathmore 112 lb.

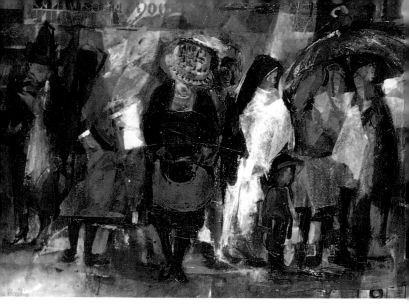

A **Hella Bailin,**
A.W.S.
Busstop
19.5" x 26" (49.5cm x 66.0cm)
Whatman cold press
Mixed media: Magazine materials,
watercolor wash, casein

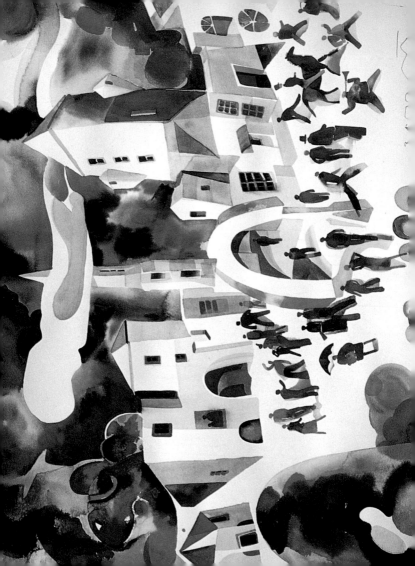

Donald Stoltenberg
Three Bridges
20" x 26" (50.8cm x 66.0cm)
Arches 300 lb. cold press

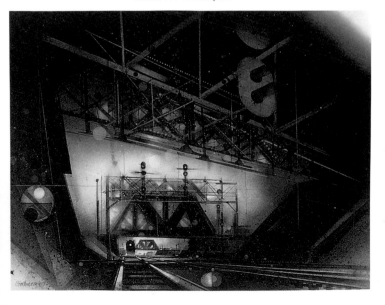

▽ **S.J. Hart**
Lamp Lit Night
10.5" x 14" (26.7cm x 35.6cm)
140 lb. Hot press

Ophelia B. Massey
Soaring
28" x 20" (71.1cm x 50.8cm)
Crescent 110 board

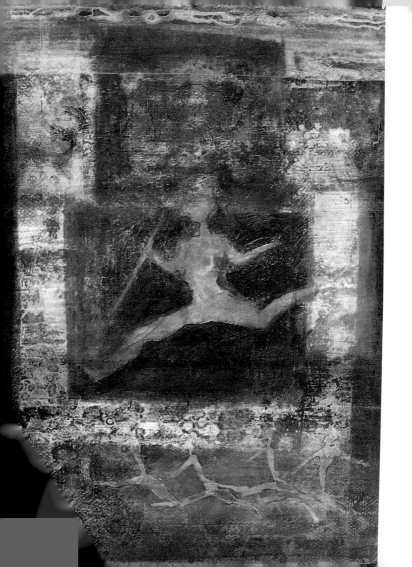

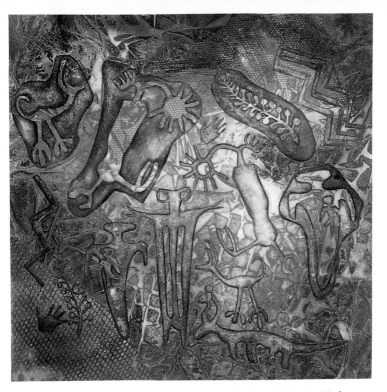

△ **Laurel Covington-Vogl**
On Their Way Home
24" x 24" (61.0cm x 61.0cm)
140 lb. Hot press
Mixed media: Wet into wet
technique

Jean H. Grastorf,
A.W.S., N.W.S.
Art Remains
28" x 20" (71.1cm x 50.8cm)
Crescent cold press

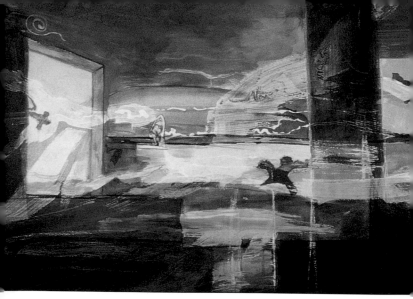

▷ **Marilyn Gross**
Thru The Looking Glass, #5
22" x 30" (55.8cm x 76.2cm)
Arches 140 lb. cold press
Mixed media: Gesso

▷ **Sandra Saitto**
Which Way Is Up?
30" x 22" (76.2cm x 55.8cm)
Arches 140 lb. cold press

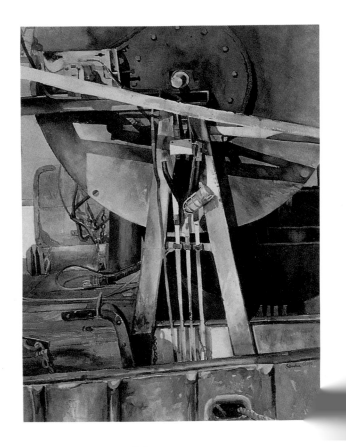

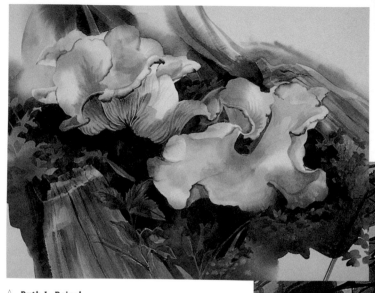

A **Ruth L. Reinel**
Humungus Fungus
15" x 22" (38.1cm x 55.8cm)
Arches 140 lb. cold press

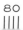

William Vasily Singelis
Poppies
22" x 30" (55.8cm x 76.2cm)
Arches 300 lb. cold press
Mixed media: Black ink

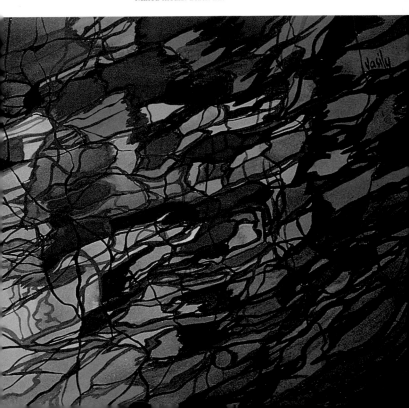

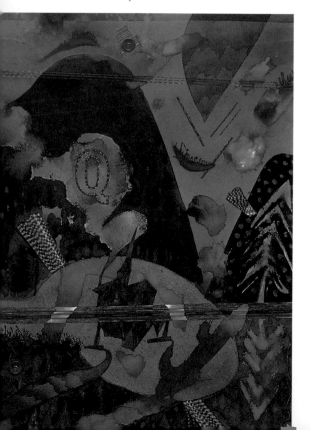

∀ **Miles G. Batt, Sr.**
Camp Q
29" x 21" (73.6cm x 53.3cm)
Arches 140 lb. cold press

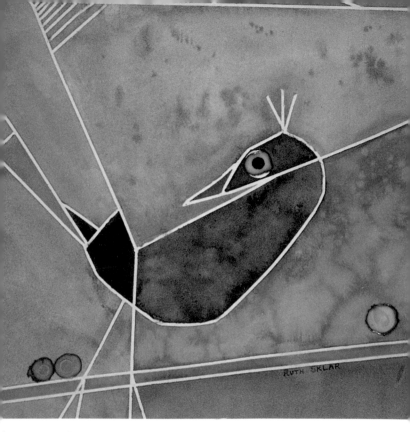

Ruth Sklar
Azteca
14.5 " x 14.5" (36.8cm x 36.8cm)
Arches 140 lb. cold press

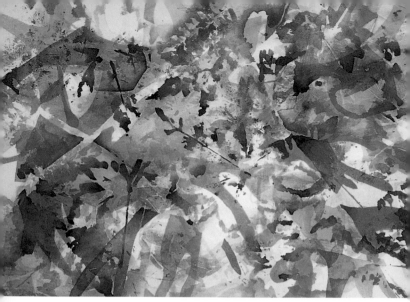

△ **Patrica A. Sarowski**
Autumn Splendor
24" x 30" (61.0cm x 76.2cm)
Arches 140 lb. cold press

▷ **Miles G. Batt, Sr.**
Golf & Stuff
29" x 21" (73.6cm x 53.3cm)
Arches 140 lb. cold press

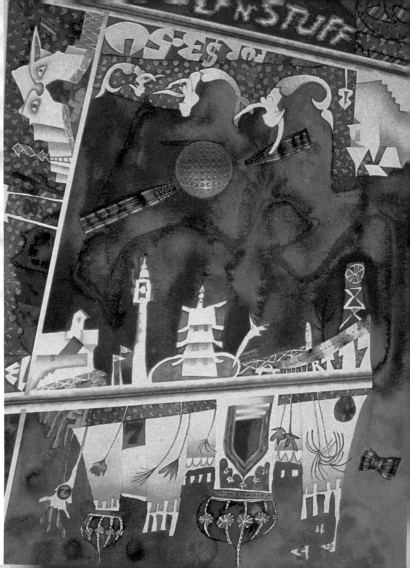

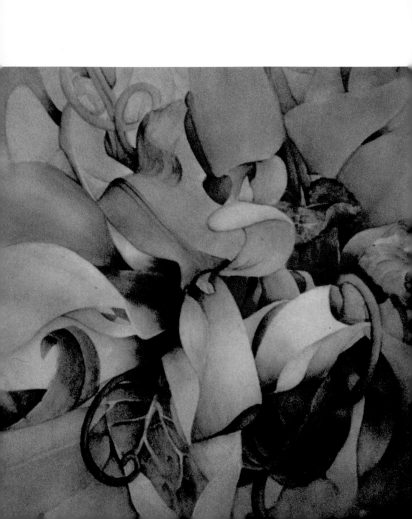

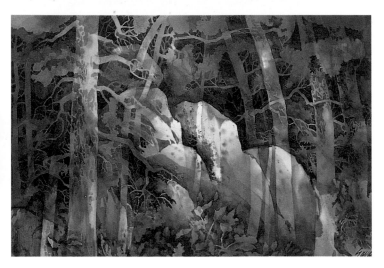

△ **Linda Savage**
Forest Tapestry
22" x 30" (55.8cm x 76.2cm)
Arches 140 lb.

Sharon Wooding
Flying Cyclamen
21" x 22" (53.3cm x 55.8cm)
Arches 300 lb. cold press

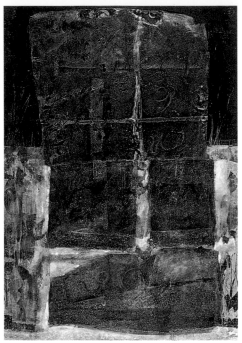

△ **Louise Cadillac**
Monolith One
30" x 22" (76.2cm x 55.8cm)
Strathmore Excalibur 80 lb. slightly textured
Mixed media: Acrylic, transparent watercolor,
watercolor crayon, pencil

▷ **Louise Cadillac**
Ritual XV
30" x 22" (76.2cm x 55.8cm)
Fabriano 140 lb. cold press
Mixed media: Acrylic, trans-
parent watercolor, watercolor
crayon, pencil

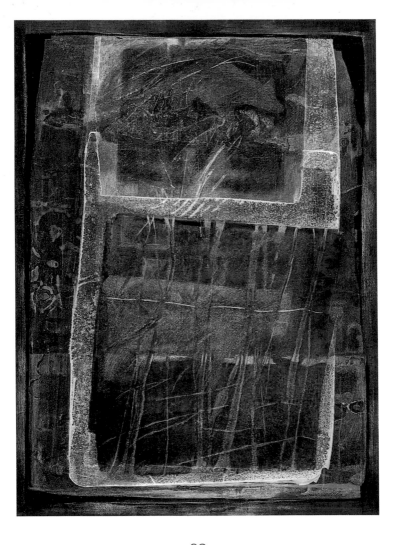

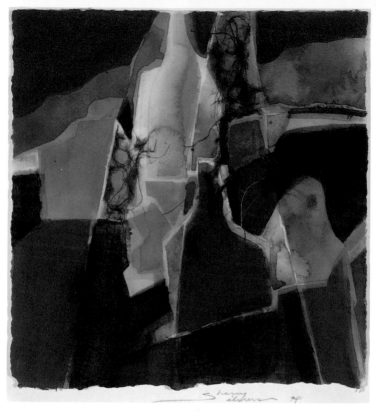

△ **Sherry Silvers**
Thoughts of Santa Fe
11" x 11.5" (28.0cm x 29.2cm)
Arches 140 lb.
Mixed media: Rice paper, string, pastel

▽ **Louise Cadillac**
Monolith Two
40" x 30" (101.6cm x 76.2cm)
Museum board smooth texture
Mixed media: Acrylic, transparent
watercolor, watercolor crayon, pencil

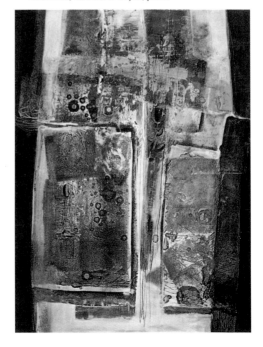

Pat San Soucie
Chromotographic Prayer Flags
39" x 28" (99.1cm x 71.1cm)
Rice papers and E.H. Saunders 140 lb.
Mixed media: Gouache

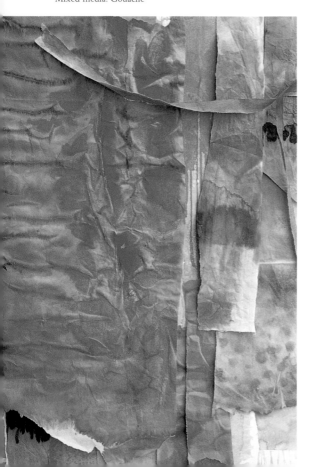

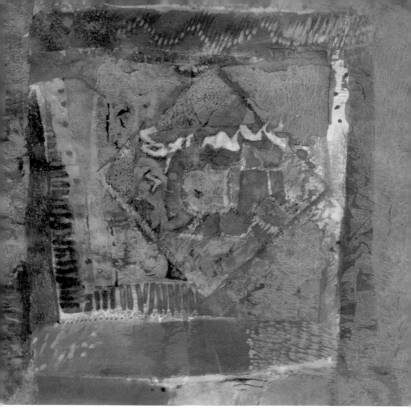

△ **Pat San Soucie**
Granny Albers' Crocheted Squares
35" x 36" (88.9cm x 91.4cm)
Arches 140 lb. hot press
Mixed media: Gouache, pen

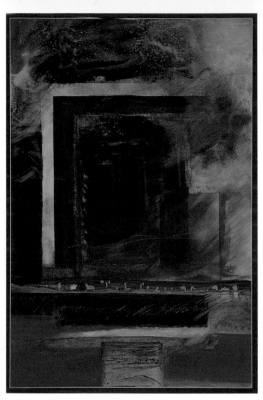

△ **Barbara Burwen**
Door to the Past
30" x 22" (76.2cm x 55.8cm)
Hot press
Mixed media: Acrylic

Lynne Kroll
36
3971 NW 101 Drive
Coral Springs, FL 33065

Jean F. Leary
71
5363 North Hayne Circle
Memphis, TN 38119

(Barbara) Ara Leites
33
18 Lehmann Drive
Rhinebeck, NY 12572

Carolyn Lord
insert
1993 De Vaca Way
Livermore, CA 94550-5609

Diane Lounsberry-Williams
67
916 Shenandoah Drive
Papillion, NE 68128

Betty Lynch
23
1500 Harvard
Midland, TX 79701

Mary Britten Lynch
29
1505 Woodnymph Trail
Lookout Mountain, TN 37350

Ophelia B. Massey
75
2610 Carriage Place
Birmingham, AL 35223

Robert Lee Mejer
68
619 Meadowlark
Quincy, IL 62301

Paul G. Melia
70
3121 Atherton Road
Dayton, Ohio 45409

Carole Myers
69
15806 Horse Creek Drive
San Antonio, TX 78232

Carla O'Connor
58
3619 - 47th Street Court NW
Gig Harbor, WA 98335

Gloria Paterson
52, 53
9090 Barnstaple Lane
Jacksonville, FL 32257

Ruth L. Reinel
80
17 W 049 Washington Street
Bensenville, IL 60106

Carol Rennick
46
1910 Route 26
Metamora, IL 61548

Patricia Reynolds
8
390 Point Road
Willsboro, NY 12996

Sue Reynolds
56
P.O. Box 2328
New Smyrna Beach, FL 32170

Joan Ashley Rothermel
64, 66
221 46th Street
Sandusky, OH 44870

Sandra Saitto
79
61 Carmel Lane
Feeding Hills, MA 01030

Patricia A. Sarowski
84
5 Pine Drive
Belleville, MI 48111

Linda Savage
87, *insert*
7910 West Red Coach Avenue
Las Vegas, NV 89129

Michael Schlicting
16
3465 NE Davis Street
Portland, OR 97232

Aida Schneider
50
31084 East Sunset Drive N
Redlands, CA 92373

Babs Scott
44
2525 Laguna Drive
Fort Lauderdale, FL 33316

Betty Sheasgreen
39
P.O. Box 828
2460 Ocean Vista Drive
Seaside, OR 97138

Marie Shell
9
724 Natures Hammock Rd. W.
Jacksonville, FL 32259

Sherry Silvers
90
405 Shallow Brook Drive
Columbia, SC 29223

William Vasily Singelis
81
25801 Lakeshore Boulevard,
#132
Euclid, OH 44132-1132

Ruth Sklar
83
14569 Benefit Street #106
Sherman Oaks, CA 91403

Pat San Soucie
92, 93
68 Dortmunder Drive
Manalapan, NJ 07726

Donald Stoltenberg
73
947 Satucket Road
Brewster, MA 02631

Betsy Dillard Stroud
49
620 Stonewall Street
Lexington, VA 24450

Anne D. Sullivan
61
28 Rindo Park Drive
Lowell, MA 01851

Roy E. Swanson
14
10409 East Watford Way
Sun Lakes, AZ 85248

Alice W. Weidenbusch
62
1480 Oakmont Place
Bluewater Bay
Niceville, FL 32578-4314

Mary Wilbanks
insert
18307 Champion Forest Drive
Spring, TX 77379

Karin Wilson
24
9800B Parkinsonia Tree Trail
Boynton Beach, FL 33436

Bernyce Alpert Winick
41, 51
923 Beth Lane
Woodmere, NY 11598

Sharon Wooding
86
Box 992
Lawrence Academy
Groton, MA 01450

Edwin H. Wordell
13
6251 Lorca Drive
San Diego, CA 92115